Designing
The New **Museum of Modern Art**

Designing
The New **Museum of Modern Art**

Glenn D. Lowry

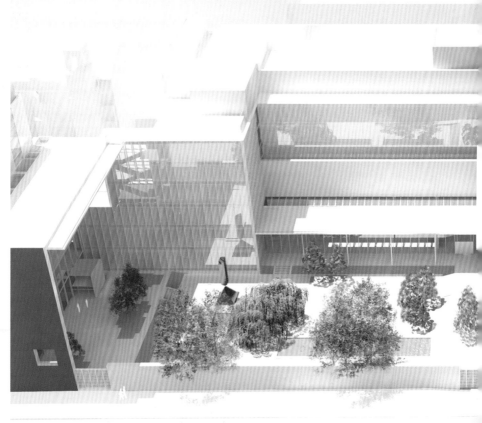

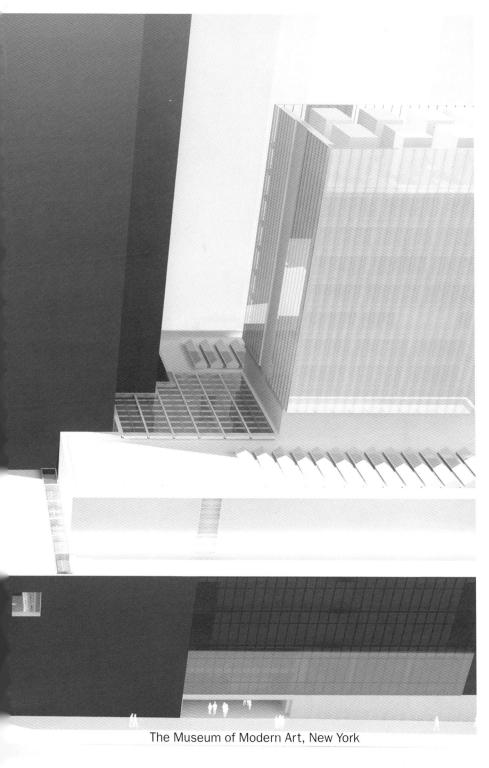

The Museum of Modern Art, New York

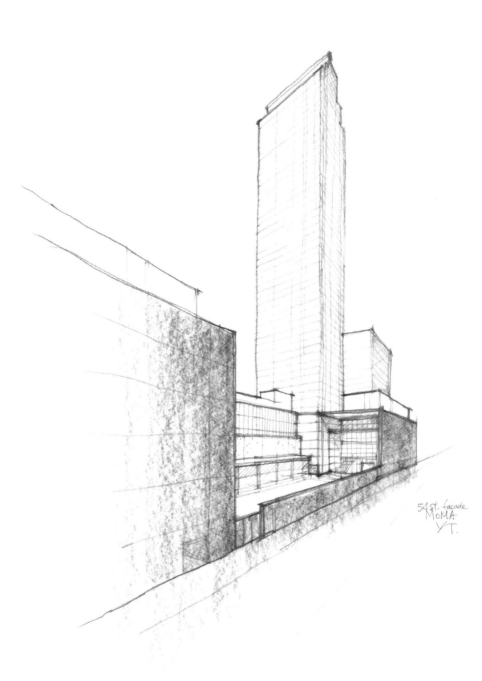

54 St. facade
MoMA
Y.T.

Drawing: Yoshio Taniguchi

Founders of
The Museum of Modern Art

The Founders of The Museum of Modern Art have provided vitally important support to the Museum, and we extend our deepest thanks for their generosity and vision.

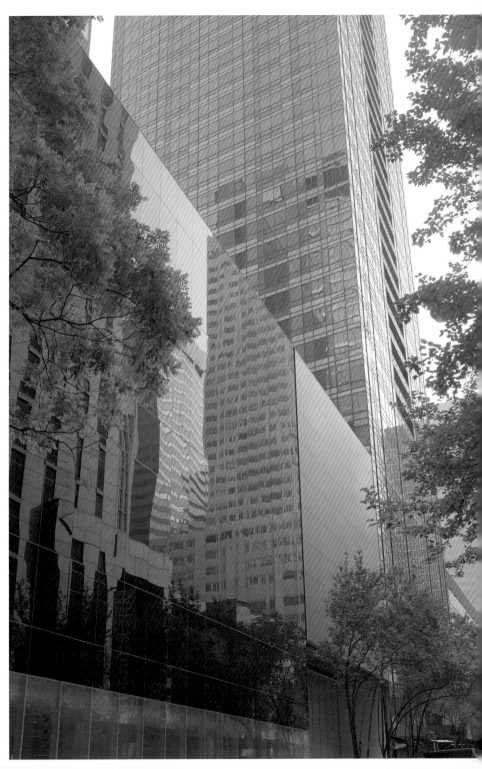

On **The** New **Museum of Modern Art**
Thoughts and Reflections

Glenn D. Lowry

On November 8, 2004, The Museum of Modern Art celebrated its seventy-fifth anniversary. At almost the same time, it completed the largest and most comprehensive building program in its history. The conjunction of these two events, though partially coinciden-tal, provides an opportunity to reflect on both the Museum's his-tory and on the directions it is going in today. A great deal, of course, has already been written about The Museum of Modern Art's evolution from a small institution founded by three remark-able women in 1929 to its current state as one of the leading institutions of its kind in the world, and there is no need to retell that story here. Instead I want to focus on what I see as the defining character of the Museum—a difficult task given the com-plexity of its history.

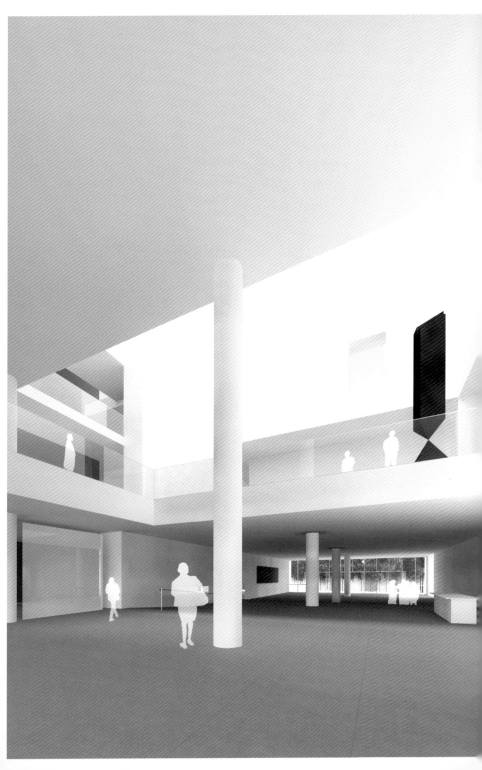

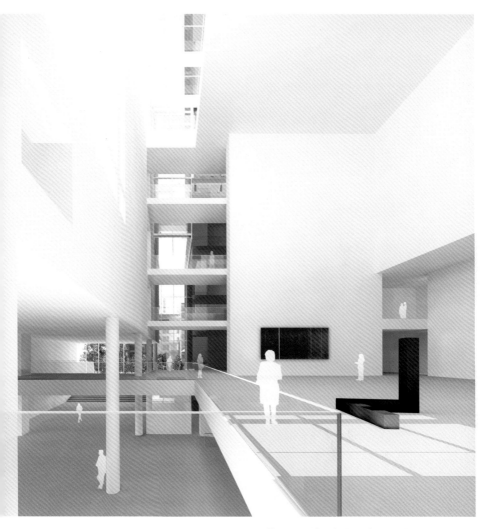

The second floor in the atrium, looking east.
Digital image

Every institution, no matter how complicated or simple, large or small, is ultimately shaped by a few overarching ideas that define its mission and goals. The British Museum, for example, founded in 1753 and a great institution by any reckoning, is still today the embodiment of the Enlightenment belief in the universality of human experience; closer to home, The Metropolitan Museum of Art is a living testament to the attempt to present an encyclopedic overview of art history to a nascent American audience. As for The Museum of Modern Art, the desire to provide a detailed but clearly intelligible history of modern art structures almost everything it does. But this desire is tempered by the reality—long recognized by the Museum—that it can never achieve this goal in any enduring way, since modern art is still unfolding and its history is still being written.

As a result, the Museum exists more as an evolving idea than as a treasure house. Alfred H. Barr, Jr., the Museum's first director, acknowledged this in 1939, a decade after the Museum's founding, in commissioning the creation of its first purpose-built home, designed by Philip L. Goodwin and Edward Durell Stone. Where many earlier museums took as their mission the preservation, display, and interpretation of their collections, The Museum of Modern Art recognized that its particular importance resided in its ability to treat its galleries as a kind of laboratory in which to engage the public with its programs and ideas. This notion of creating a museum that was both popular and populist in spirit led the institution to break away from the prevailing architectural language used for museums at the time—a language heavily reliant on classical and neoclassical references—and to adopt the vocabulary of international modernism. It also led the Museum to place its entrance directly on the street, instead of up the imposing flight of stairs used by many other museums to set them-

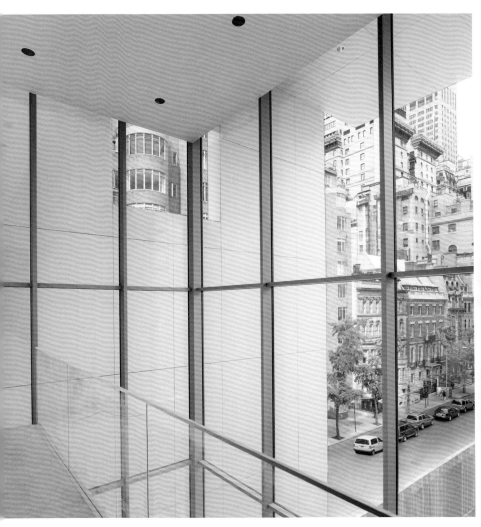

View from the fourth floor of the gallery building
toward 54th Street

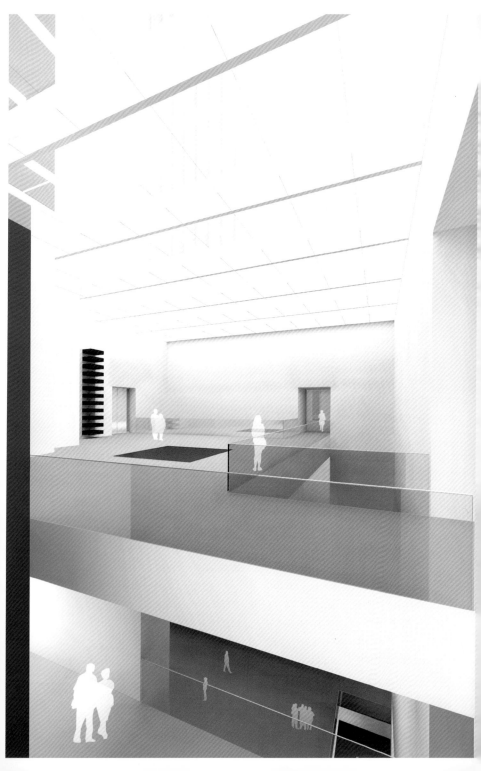

selves apart from urban activity and noise. In doing so the Museum radically altered its relationship with the public and with the city, declaring that it was to be understood not as a quiet sanctuary but as part of the hectic and ever changing life of its metropolitan setting.

The idea of the Museum as a laboratory meant that it accepted the challenge of being in constant flux, evolving and changing as modern art, and our understanding of modern art, evolved and changed. Even the way the Museum refers to itself has been adjusted several times, from the early, unabridged appellation "The Museum of Modern Art," to "the Modern" in the 1950s and '60s, and now to "MoMA." This metamorphosis is paralleled in the museum's typeface, which has evolved from the geometric, Bauhaus-inspired characters of 1929 to today's Franklin Gothic no. 2, as digitized and redesigned by Matthew Carter in 2003. Born of a fundamental conviction that modern art (that is, the art of our time) is as exciting and important as the art of the past, and that the pleasures and lessons of engagement with it should be shared with as large a public as possible, the Museum has functioned as a kind of ongoing experiment. For Barr this meant that after the close of the inaugural exhibition in the new building in 1939, "The various departments, those already in existence and those in formation, will gradually be established in more or less permanent exhibition galleries on the second and third floor of the new building. Just how these galleries will be arranged will depend to a considerable degree upon the public's response to the present exhibition. Nothing that the visitors will see in the exhibition galleries; neither the works of art, nor the lighting fixtures, nor even the partitions, is at present permanent."

Over the next sixty years The Museum of Modern Art underwent six major building campaigns and expansions: in 1949–51

with the construction of Philip Johnson's Grace Rainey Rogers Annex, immediately west of the Goodwin and Stone building, with a facade on 53rd Street; in 1952–53 with the formal creation of The Abby Aldrich Rockefeller Sculpture Garden, designed by Johnson; in 1963–68 with the incorporation of the building of our former neighbor the Whitney Museum of American Art, designed by Johnson and Augustus Noel, into the fabric of the Museum; in 1964 with the addition of Johnson's East Wing; in 1979–84 with the addition of Cesar Pelli's tower and expansion; and most recently with Yoshio Taniguchi's redesign of the Museum's entire campus. Each of these projects can be seen as addressing the changing nature of the institution, expanding and altering its spaces to adapt to a dramatically enlarged collection, a constantly growing public, and an increasingly complex and nuanced understanding of modern art.

Museums are above all venues of artistic and intellectual inquiry and this is especially true of The Museum of Modern Art, where several generations of scholarship have shaped and reshaped the way we see and understand the art of our time. This process began with the Museum's very first exhibition in that opening year of 1929, *Cézanne, Gauguin, Seurat, Van Gogh*, which sought to identify modern art's roots in Post-Impressionism. Shows of the 1930s and '40s examined folk art, African-American art, prehistoric rock paintings, arts of the native peoples of the North and South Americas, and other such traditions with an eye to their relevance to modern art, and installations of the permanent galleries through the 1970s and '80s endeavored to establish and explicate a history of modern art. Modern art, however, is resistant to simplification and organization, as Barr clearly showed in the interlocking and overlapping lines of his legendary diagrams tracing modernism's sources and routes of development.

Nevertheless, as the Museum's programs became increasingly successful and its collection acquired almost legendary status, the provisional, exploratory nature of the institution's early exhibition and collection program gave way to an accepted canon. The history of modern art was laid out in a series of linked rooms that purported to tell a single coherent story; the temporary lighting fixtures and partitions of 1939 became fixed units and walls.

But if the Museum was understood in its early years to be a laboratory, it was also understood to be metabolic or self-renewing, in terms of both its collection (which was meant to grow through acquisitions and to be refined through careful deaccessioning) and its exhibition program, in which each exhibition, and each installation of the collection, was seen as presenting not a definitive statement but an argument about the history of modern art. In this way the Museum's program can be seen as a series of hypotheses about how modern art can be read at any given moment, subject to review and modification as the art itself changes, and as we gain greater insight into a tradition that is still unfolding. Put differently, The Museum of Modern Art is constantly revising the narrative of its own history, tracing what Proust called "*le fil des heures, l'ordre des années et des mondes*"—the continuous thread through which selfhood is sewn into the fabric of a lifetime's experience. This is a collective process of interlocking dialogues and narratives played out over a theoretically infinite number of lifetimes. Each thread, each experience, is part of an ever-expanding set of ideas and realities made concrete by the objects that the Museum collects and displays. As each of these narratives is encoded into the pattern of the Museum's history through acquisitions, exhibitions, publications, and programs, it inflects and alters the Museum's intellectual and physical space.

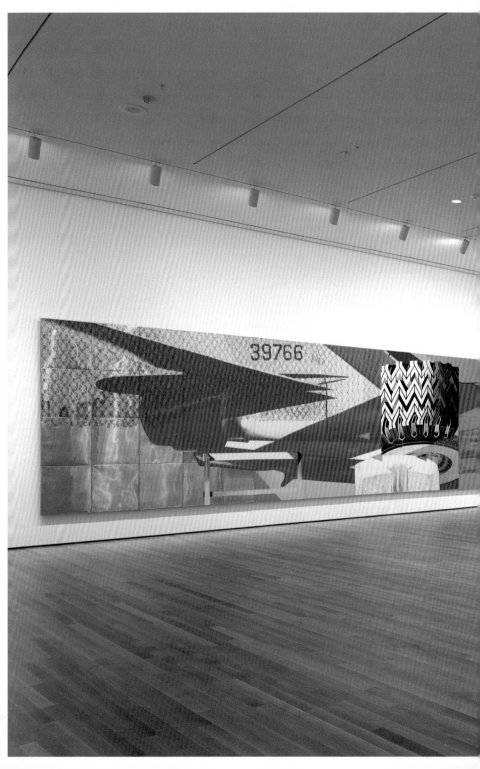

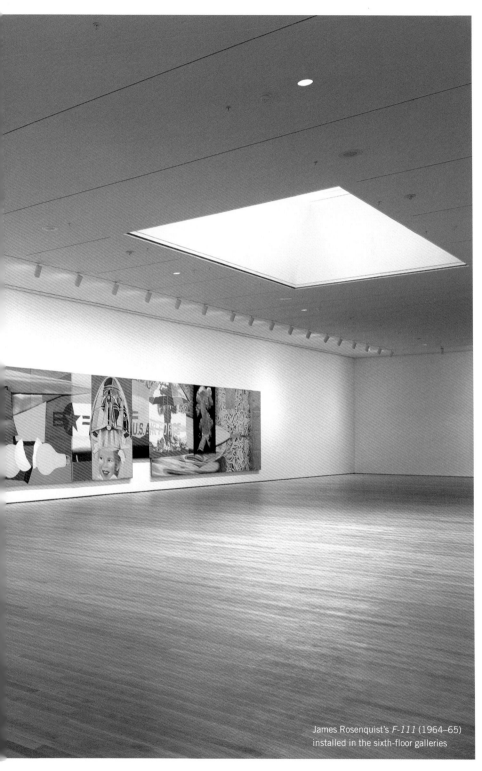

James Rosenquist's *F-111* (1964–65)
installed in the sixth-floor galleries

Drawing: Yoshio Taniguchi

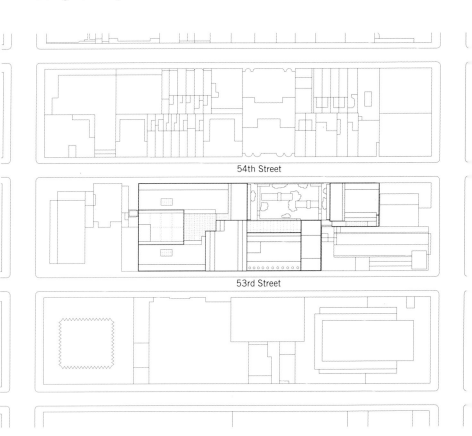

54th Street

53rd Street

Site plan

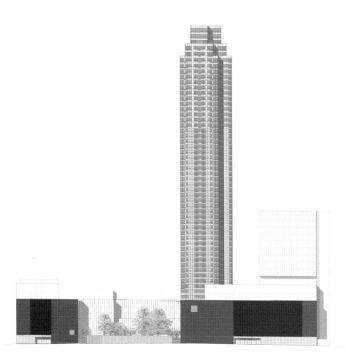

North elevation, 54th Street

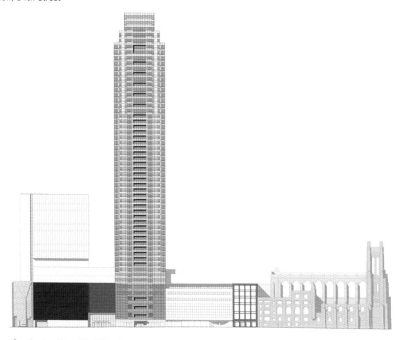

South elevation, 53rd Street

The challenge, then, for the Museum throughout the 1990s was how to extend and enhance the presentation of its collection while addressing a number of longer-term needs, such as the requirement for over 100,000 square feet of storage space to house a collection that had grown from 64,000 objects in 1980 to over 100,000 in 1995. Among the most pressing issues for the Museum was how to deal with the programmatic and physical needs of specifically contemporary art while retaining the ability to present a synoptic overview of the collection, as well as how to accommodate an audience that had doubled— from 900,000 people a year to over 1.8 million—in less than a decade. This was ultimately a question of balancing the spatial requirements of contemporary art with those of the more histori- cal dimensions of the collection, and also of creating sequences of galleries that would permit a more open, less structured move- ment through the Museum while retaining a sense of intimacy in the overall feel of the spaces.

A number of options were available, from ceasing to col- lect contemporary art all together—never a serious possibility— to establishing a separate museum for contemporary art, which, however, in establishing a division between the earliest and the most recent works in the collection, would have created more problems than it solved. In 1998, the Museum did decide to merge with the P.S. 1 Contemporary Art Center in Long Island City, Queens, extending its contemporary initiatives through P.S. 1's already existing programs. What gives the Museum its unique mis- sion and role, though, is the address of precisely this constantly shifting juncture between the immediate past and the present. To deal with the needs of contemporary art as an institution, it was imperative to find a way to build sufficiently large and flexible gal- leries to accommodate that art without distracting from the earlier

parts of the collection. It was also clear that in order to present a more synthetic and complex overview of the early and current collection as a whole, the Museum needed not only more galleries but an organization of those galleries that would give visitors a variety of options in moving through them, allowing for a more nuanced, less linear sense of art history by encouraging serendipitous discoveries and juxtapositions.

By the mid-1990s it was evident that the only viable solution to the Museum's requirements was to expand on 53rd Street, an almost impossible task given the reality of midtown-Manhattan real estate. In 1996, however, the Dorset Hotel on 54th Street, to the Museum's northwest, and several adjacent brownstones on 53rd and 54th streets became available for purchase. The answer to the Museum's needs was suddenly clear.

The Museum immediately acquired these properties and began the search for an architect. In 1997, it hired Yoshio Taniguchi, asking him not only to expand MoMA's building but to rethink all of its conjoined parts, accreted over time, in order to create a fully integrated structure—in short, to build an entirely new Museum of Modern Art. At the same time, the Museum also undertook to find space outside Manhattan for a state-of-the-art study and storage center. The result is MoMA QNS, a 160,000-square-foot facility in a renovated factory in Long Island City. As redesigned by Scott Newman, of Cooper Robertson and Partners, and Michael Maltzan, this building temporarily served as the Museum's exhibition space from 2002 to 2004, while its new Manhattan building was under construction.

From the outset the Museum set several goals for its 53rd Street project—some practical, some more abstract. These included the need to find a way to conceive its space, rather than simply plan its architecture, so that the predictable order of the

Following spread: Michael Wesely. *9.8.2000–2.5.2003. The Museum of Modern Art, New York*. Chromogenic color print

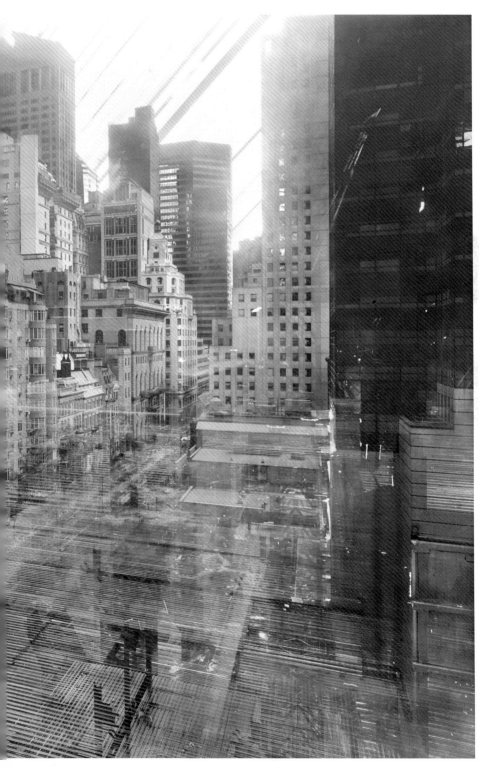

Museum could engage with the unpredictable order of the city, while simultaneously recognizing the heightened challenge of mediating between the experience of the city and that of looking at art. In order to stay "modern," the Museum had to avoid becoming merely a treasure house or vault for its collection; it had to assert its commitment to contemporary art; and finally it had to diversify and enrich the experience of looking at modern art to keep that experience engaging and pleasurable. Within this context it was understood that any solution to the Museum's architectural problems would have to recognize the heterotopic nature of its various buildings, even while knitting them into a unified entity. (This sense of the Museum as made up of many parts was reflected in the new building's interior by asking Richard Gluckman, of Gluckman Maynard, to design the Museum Store on 53rd Street, the Reading Room on the second floor, and the retail kiosk on the sixth floor, and Bentel and Bentel to design the restaurant on the ground floor and the café on the second floor.)

Taniguchi's design is a brilliant response to both the Museum's urban context and its programmatic requirements. The design takes advantage of the Museum's unique position in midtown Manhattan, where it straddles one of the city's busiest commercial districts to the south and a residential neighborhood to the north. The project comprises five parts: a new galley complex with a ten-floor tower above it, named in honor of David and Peggy Rockefeller, on the site's west side, where the Dorset Hotel and several brownstones used to be; the renovated Goodwin and Stone building of 1939 and Johnson building of 1964, now named in honor of Ronald and Jo Carole Lauder; The Abby Aldrich Rockefeller Sculpture Garden; and the Education and Research Building on the northeast corner of the site, housing a theater, classrooms, curatorial offices, study centers, and the Library and

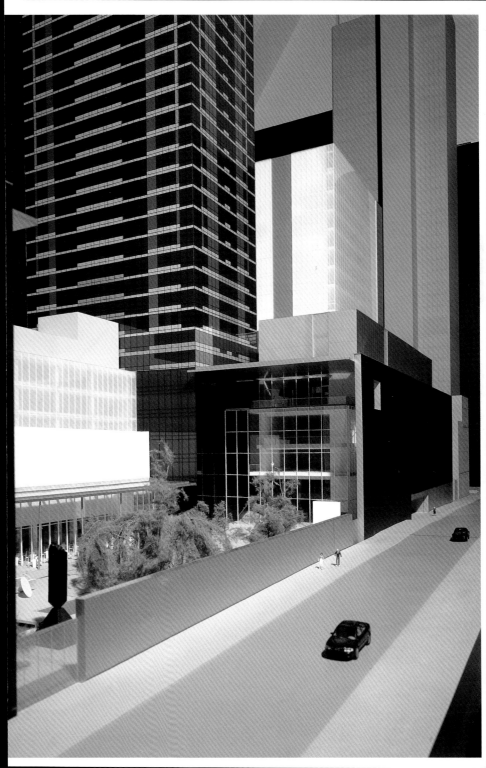

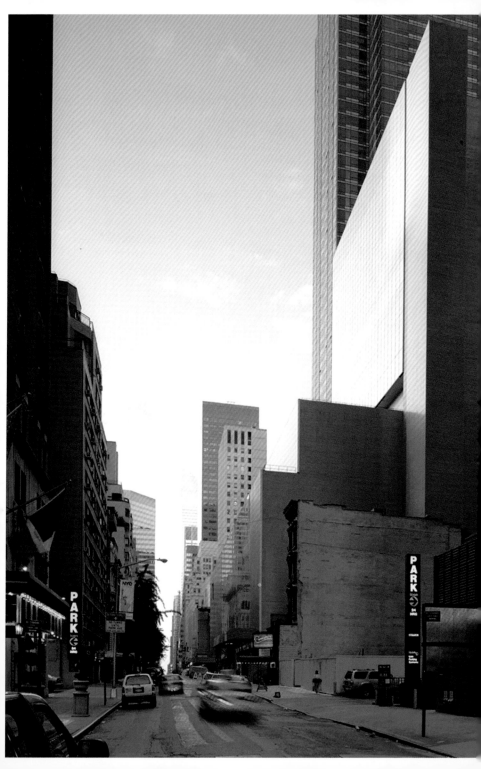

Archives, and named in honor of Lewis and Dorothy Cullman. Rising through the middle of the complex is Pelli's fifty-four-story residential tower (part of the Museum's 1979–84 expansion), the lower seven floors of which are incorporated into the project. Taniguchi based several strategic decisions on the Museum's midtown location. First, he recognized the simultaneously commercial and residential nature of the area by developing two different facades. To the south, along 53rd Street, he preserved the Johnson, Goodwin and Stone, and Pelli facades while adding one for the new gallery complex to their west, thereby articulating the Museum's historical development while responding to the heterogeneity of midtown Manhattan's commercial buildings. To the north, along 54th Street, meanwhile, he created a single, unified facade of Zimbabwean black granite, dark gray glass, glass finely fritted in alternately clear and white lines, and aluminum. This front stretches all the way from the new gallery complex on the Museum's west end to the Education and Research Building on its east. Restrained and quiet, the facade acknowledges the residential nature of 54th Street while defining the Museum as a single, fully integrated complex.

Taniguchi's second move was to address Pelli's residential tower, which cuts through the middle of the Museum's site. Rather than disguise this protrusion, Taniguchi decisively took advantage of it by articulating in dark gray glass the northeast and northwest corners of its lower seven floors, making it a central axis point for the complex and providing a locus of orientation for a site that now totals over 640,000 square feet. This articulation also helps to establish the joint between the garden, the Goodwin and Stone building, and the new galleries as a kind of pivot point between the historical and the new, the interior and the exterior, and several of the principal circulation systems

he 54th Street facade from the west

which rise along the side of the tower's core.

Finally Taniguchi decided to emphasize The Abby Aldrich Rockefeller Sculpture Garden as the heart of the entire complex. His means was to make the garden larger: while retaining its existing layout, he expanded it by recovering its south terrace, which had been incorporated into the Garden Hall of Pelli's 1979–84 addition. He also extended its east and west terraces and framed them with two giant porticoes—one opening out from the gallery complex, the other opening from the Education and Research Building. Between these two wings, on the ground level of the Goodwin and Stone and Johnson buildings, Taniguchi relocated the Museum's restaurant to open directly onto the Garden's south terrace, while also being accessible from 53rd Street, to the south.

The porticoes of the gallery complex and the Education and Research Building not only define the east and west facades of the Garden but establish a symmetrical horizontal axis that balances the vertical one of the Pelli tower. They also link the two halves of the Museum, reflecting the institution's commitment to education and research as well as to the exhibitions and public programs that result from them. In making the two halves of the Museum mirror each other in this way, Taniguchi has consciously transformed the site into a metaphor for the institution itself as a laboratory of learning. This understanding of the museum is further emphasized by the massive windows beneath the porticoes' canopies, which allow the public to see into the gallery complex and the Education and Research Building from the garden and the street. The activity of the Museum is thus open to the city, and is animated in turn by the city's vitality and energy.

To the west of Pelli's tower, the design creates a block-long ground-level lobby from 53rd Street to 54th. Elevators, stairs, and an escalator allow visitors to move easily from here to the

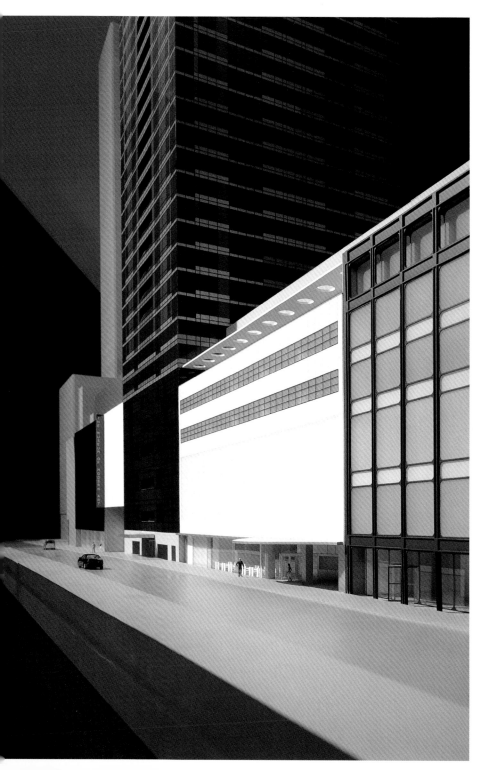

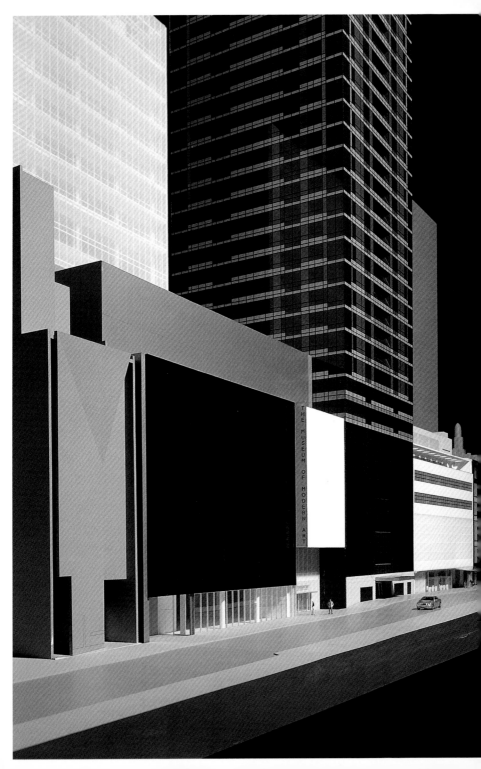

second floor, a kind of piano nobile providing access to galleries, a six-story skylit atrium, a reading room, a café, and the Education and Research Building. Taniguchi's most dramatic gesture, however, was to reverse the sequence of the collection galleries: visitors encounter the contemporary galleries first, on the second floor. Should they move from here to the next set of collection galleries, on the fourth floor (there is no third floor in the western part of the building, since the second floor is double height), and then to the final set, on the fifth, in terms of the art they see they will progressively move backward in time—since it is the fifth-floor galleries that cover the earliest years of the collection. This choice of Taniguchi's simultaneously solved an engineering and a programmatic problem. By placing the contemporary galleries on the second floor, Taniguchi was able to get the high ceilings (twenty-one feet) needed for the display of so much contemporary art, to free the space of columns, and to provide a sliding door so that oversized sculpture can be gantried in from the street, which would have been impossible on the fourth and fifth floors. At the same time, by making the contemporary galleries the first suite of galleries that visitors meet, Taniguchi found a way to make physically evident the Museum's commitment to contemporary art, embedding this programmatic direction of the institution in the architecture of the building.

If it is the contemporary galleries that provide the entrance into the Museum's collection, that collection itself is revealed through a series of departmental and collection galleries that follow the general organization developed by the Museum in the late 1970s and early '80s. The film theaters stay on the mezzanine and lower level, with the additions of a new theater in the Education and Research Building and of a "black box" gallery for media on the second floor of Taniguchi's new tower, adjacent to

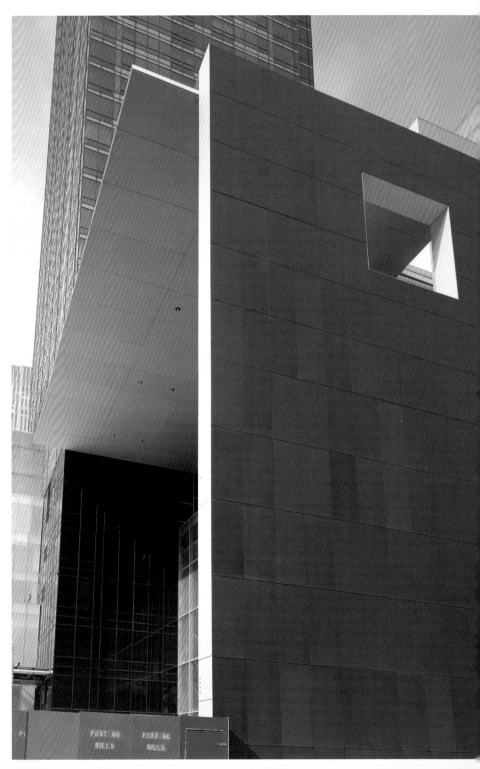

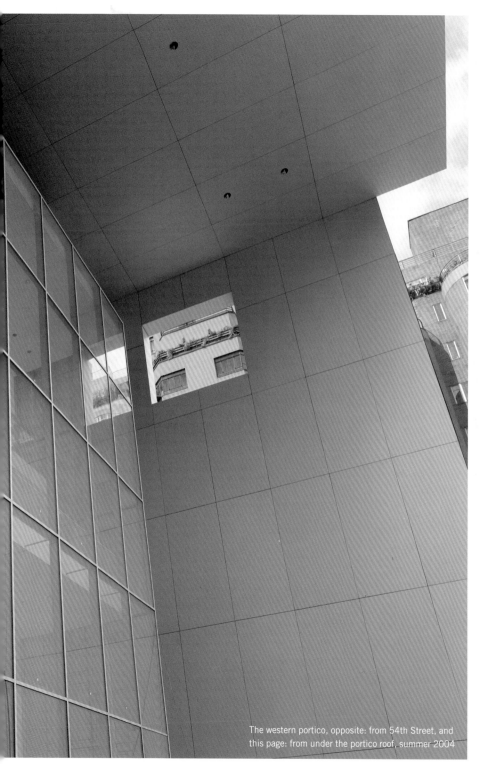

The western portico, opposite: from 54th Street, and
this page: from under the portico roof, summer 2004

the contemporary galleries. The departmental gallery for Prints and Illustrated Books, in the "podium" formed by the conjunction of the Goodwin and Stone building and the Pelli tower, is also nearby, since all of these spaces, old and new, are interconnected; the Drawings and the Photography galleries are also in the podium, and the Architecture and Design galleries lie in the easternmost section of the new gallery complex. Here the Museum's curatorial departments can present detailed views of their holdings and explore issues specific to the media they represent.

At the core of the Museum's presentation of its collection are the galleries primarily devoted to painting and sculpture on the fourth and fifth floors of The David and Peggy Rockefeller Building. These galleries comprise a series of fixed and variable spaces. The fixed spaces are designed to present a synoptic overview of the Museum's collection, from the late nineteenth century on the fifth floor to the 1970s on the fourth. They are fixed in the sense that the works of art displayed in them will likely remain on view for a considerable period of time. The variable spaces are designed to interrupt and amplify the fixed ones, providing an opportunity to inflect their synoptic overview—by highlighting the work of an individual artist, say, or by exploring an issue or idea at a level of detail that would be impossible in the fixed spaces. The variability of these spaces lies in the fact that they will be reinstalled on a more frequent basis than the fixed galleries.

In addition to painting and sculpture, the fixed and more particularly the variable galleries will include works from all of the Museum's departments. Thus a variable space devoted, for example, to Cubism might include paintings, sculptures, drawings, and prints, while another devoted to Surrealism might extend to photography and film. Conversely, works from the painting and sculpture collection may sometimes appear in other departmen-

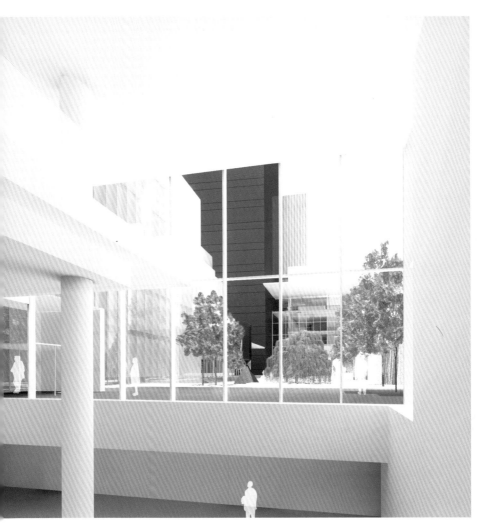

Inside the Education and Research Building, looking west toward the Sculpture Garden. Digital image

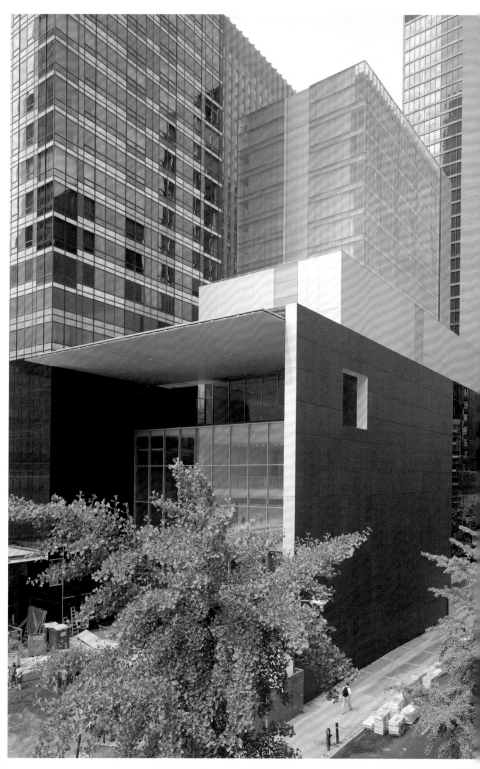

tal galleries. This "porous" approach is designed to open up dialogues among media, allowing the visitor to see the Museum's collection as a whole rather than as a series of discrete parts.

The Museum that is revealed by this new installation plan is but another iteration of The Museum of Modern Art envisioned by its founders over seventy-five years ago. It is larger, of course, and more complex, but its underlying principles endure. For it is inherent in the Museum's conception of itself that the installation of its collection be provisional. Each installation is an experiment, a variation on a theme, providing an opportunity to reconsider the collection in its entirety and then to use that knowledge to revise, enhance, and alter the way the collection is presented in the future—and, in so doing, to arrive at new understandings. The new Museum of Modern Art, like the old Museum of Modern of Art, is a work in progress in which the public is invited to participate. As such, it is a fundamentally humanistic endeavor that extends the Enlightenment notion of the museum as a place of knowledge and inquiry into the twenty-first century.

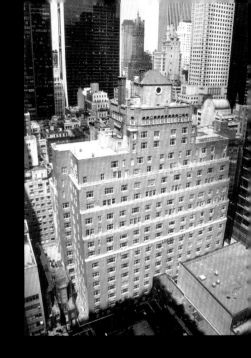

Dear Colleagues:

This publication celebrates almost a decade of hard work and remarkable effort on your part. From the conceptualization of the new Museum, to the selection of Yoshio Taniguchi, to the successful opening of MoMA QNS in 2002, through the construction and opening of the new Museum, you have played an instrumental role. All great institutions are the sum of their parts and The Museum of Modern Art is blessed in its dedicated and talented staff. The challenges of the last decade have been enormous and have required skill, intelligence, and dedication, and on behalf of the Trustees of the Museum, I salute you. The new Museum is a tribute to—and a reflection of—every one of you.

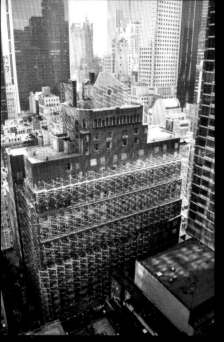
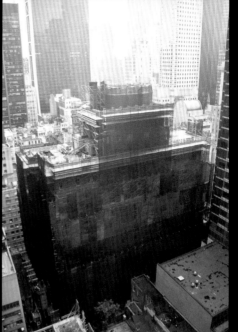

Staff of
The Museum of Modern Art

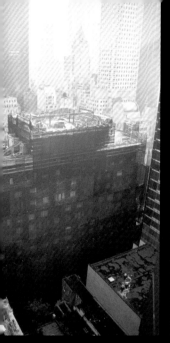
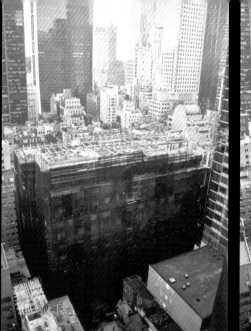
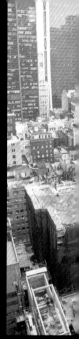

Serge A. Barrantes
Beverley A. Bascom
Kevin Bascome
Miriam M. Basilio
Romane Bazile
Louis Bedard
Stacy Beggi
Laura H. Beiles
John Beleckis
Sally Berger
Oliver B. Berkman
Arthur Berwick
Tamiko Bey Collier
Simon Bieling

Klaus Biesenbach
Jayathirth Biradar
Todd Bishop
Julia Bissell
Randolph Black
Sara Grace Bodinson
Christine M. Boily
Jean Mary Bongiorno
Dragos A. Bonica
Alfred Boozer
Jean D. Borgella
Dawn H. Bossman
Majlena Braun
Caroline Bretter

Sydney Briggs
Maurice Brown
Sean Brown
Aziza Browne
Danny Bruno
Karl D. Buchberg
Barbara Bunton
Elizabeth Burke
Allegra Burnette
James W. Burns
Fimbar Byam
Christopher Byrd
Joseph P. Campbell
Rafael Candelaria

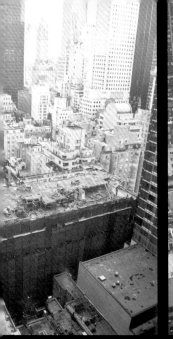
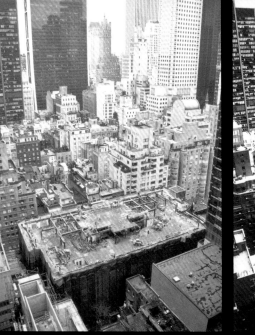

Pat Caponigro
Taina B. Caragol
Juan Carbia
Daniela Carboneri
Benjamin Carrero
Michael Cary
Stacey A. Castagna
Antonio Castillo
Anthony M. Castro
Mabbel Cedano
Fatima Cevallos
Fernanda G. Chandoha
David Charles
Sharon Charles

Harold Chi
Hsien-Yin Ingrid Chou
Audrey Christensen
Rene Cifuentes
Dennis Cintron
Stephen Clark
Catherine Cleary
James Coddington
Benjamin Codrington
Carol E. Coffin
Elan Cole
Jose Colon
Ellen Conti

Corey Cook
Richard J. Cook
Claire E. Corey
Celestino Cornacchio
Christopher Coronel
Chere L. Costello
Stephen Cramer
Rachel A. Crognale
Curtis B. Croome
Perry S. Cruiz
Hope R. Cullinan
James H. Culpepper
Jennifer Cummins
Kathleen S. Curry

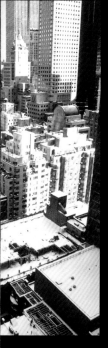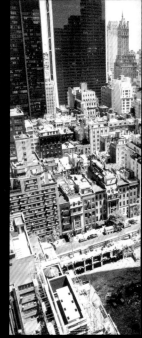

Lee Ann Daffner
Fereshteh Daftari
Sonja C. Dagress
Amy D'Ambrosio
John S. D'Ambrosio
Jessica Damrow
Javier A. Daniel
Shannon N. Darrough
Karen Davidson
Levar H. Dawkins
Sara A. de Leon
Maria DeMarco

Sharon B. Dec
Howard L. Deitch
George DeLuisi
Margaret J. D'Errico
Marlene Diaz
Tina Marie DiCarlo
Sam Dickerson
Monika M. Dillon
Edmund D'Inzillo
Kim J. Donica
Kimberly Donovan
John F. Dooley

Faith Dowgin
Margaret M. Doyle
Amy Draemel
James D. Drumheller
Stacey S. DuBose
Michael C. Duffy
Afrim Dzemaili
Ezekiel Ebinum
Vernon E. Edwards
Sean Egan
John Elderfield
Michelle R. Elligott

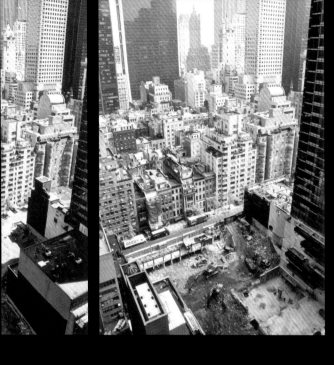
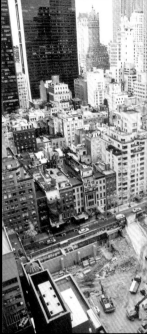

Daniel A. Fermon
Jennifer Field
Mark A. Fields
Mary Starr Figura
Kanitra S. Fletcher
Seth Fogelman
Peter Foley
Joseph Fonte
Leah Fox
David S. Frankel
Jessica A. Friday
David L. Friedman

Moises D. Funez
Peter J. Galassi
John J. Gallagher
Sarah Ganz-Blythe
James Gara
Hayna J. Garcia
Paulino Garcia
Richard T. Garcia
Santos Garcia
Yesenia Garcia
Lionel Garraway
Gary Garrels

Bruce Gaynor
Peter Geraci
Scott R. Gerson
Vincent Ghirawoo
Miriam Gianni
Claire S. Gilman
Dirk O. Glasgow
Fred Goldberg
Nicole L. Goldberg
Basilio A. Golden
Michele R. Goldsmith
Leigh M. Goldstein

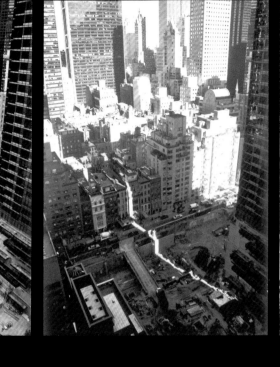
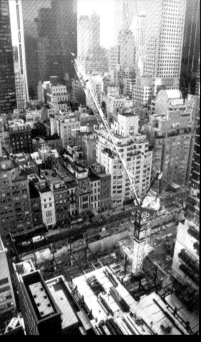

Jacque D. Goode
Amy E. Gordon
Melissa M. Gordon
Theodore A. Gorodetzky-
 Grayson
Ian Goulston
David Green
Joanne F. Greenspun
Bradford Greenwood
Stanley W. Gregory
John R. Greiner
Thomas J. Griesel
Albert R. Griffith

Christina D. Grillo
Thomas D. Grischkowsky
Frantz Guillaume
Thomas J. Gureck
Andrew Haas
Angela L. Hamilton
Mary Hannah
Michelle L. Harvey
Aynsley Harwell
Jeffrey N. Harwoods
Robert Hastings
Jodi Hauptman
Lisa Hawkins
Barbara A. Hayes

Jenny He
Judith B. Hecker
Stacey Heim Lee
Alanna Heiss
Cassandra Heliczer
Claire Henry
Jennifer M. Herman
Mattias G. Herold
Steven Higgins
Natalie Hirniak
Deborah Hoffman
David Hollely
Christel Hollevoet-Force

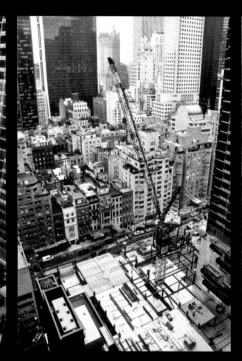
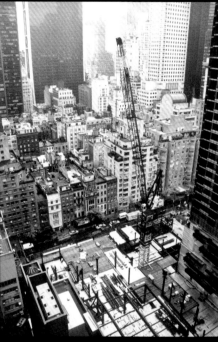

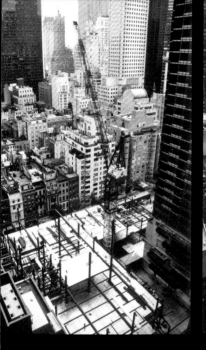
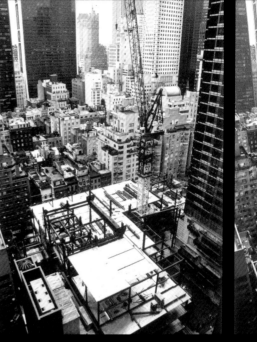

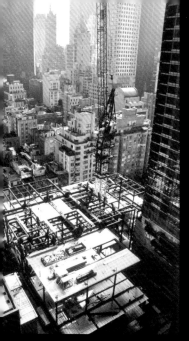
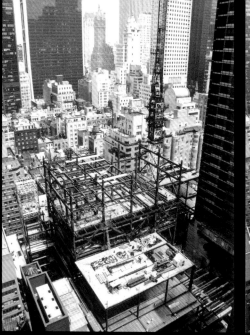

Latesha S. Lucas-Key
Maggie Lyko
Maura A. Lynch
Katherine Lyons
Carolyn Mackay
Karen L. Madden
Michael P. Maegraith
Ronald S. Magliozzi
Burns Magruder
Mehrdad Mahamedi
Melanie Malkin
Brian J. Maloney
William J. Maloney
John T. Manna

Robert J. Manning
Jennifer M. Manno
Lisa A. Mantone Vilardi
Roxana Marcoci
Michael R. Margitich
Elizabeth Margulies
John E. Martin
Lori Ann Martin
Maria R. Martin
Raymond Martin
Raymond A. Martinelli
Richard G. Mawhinney
Heather Maxson

Stefan E. Maxwell
Susan McCullough
Katherine J. McDonald
David McDonnell
Carrie L. McGee
Christopher McGlinchey
Catherine S. McGovern
Kenneth McIver
Thomas V. McLoughlin
Tim McManus
John C. McPherson Jr.
Kynaston L. McShine
Mohammed M. Meah
Richard A. Mealey

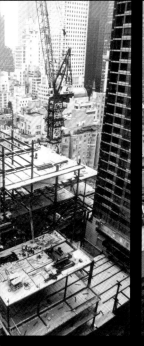
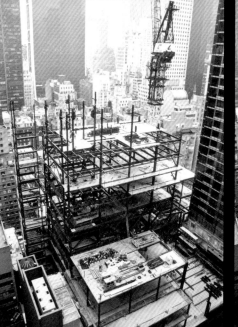
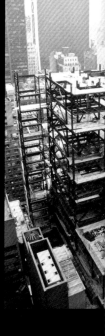

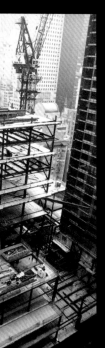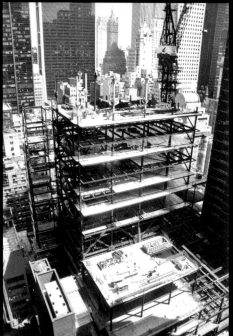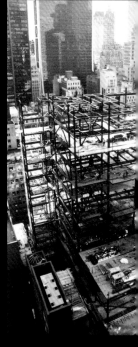

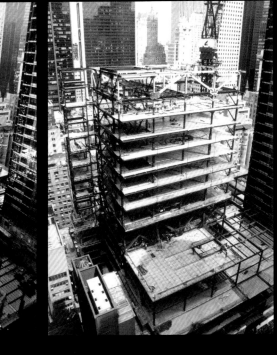
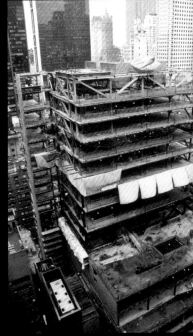

Bhanmatie Perlow	Lisa Polay	Margaret J. Raimondi
Deborah Perotti	Leal V. Powell	Bonnie Ralston
Ethan W. Perry	Paul Power	Maria Ramirez
Jason W. Persse	John Prochilo	Wilfredo Ramos
Elizabeth H. Peterson	Tanya L. Puccini	Nancy M. Read

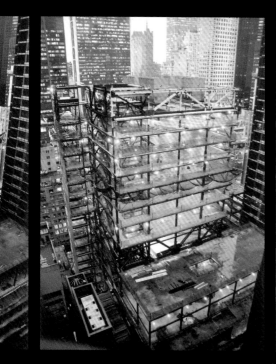
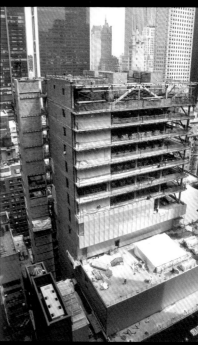

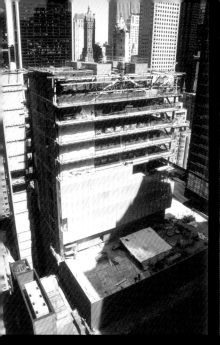
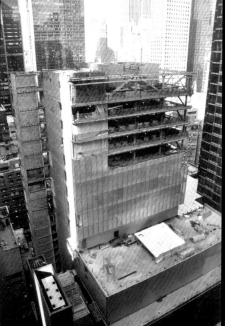

Joshua Siegel
Charles Silver
Jack F. Siman
Ann R. Simmons
Victor Simmons
Barbara D. Simon
Ronald A. Simoncini
Diana L. Simpson
Gregory Singer
Martha C. Singer
George Sivulka
Matthew R. Skopek
Allan G. Smith

Esmay E. Smith
Kathleen R. Smith
Leon Smith
Rosa Laster Smith
Whitney J. Snyder
Julia E. Sobol
Joel R. Soliven
Jean Solomon
Lauren J. Solotoff
Peter S. Sordan
Eliza K. Sparacino
Mara W. Sprafkin

Leslie M. Stabiner
Bryan K. Stauss
Siri Lauren Steinberg
Fabienne Stephan
Rebecca H. Stokes
Gary I. Stoppelman
Ramakrishna
 Sudheendra
Anna Sukhareva
Sarah R. Supcoff
Sarah Suzuki
Mark Swartz
Anna M. Swinbourne

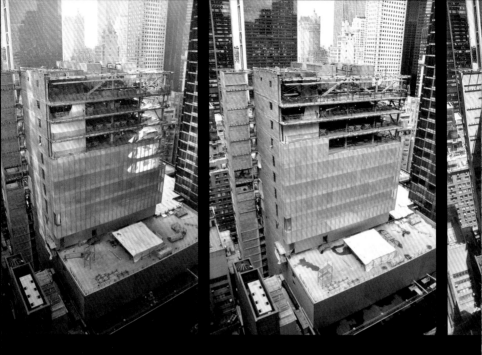

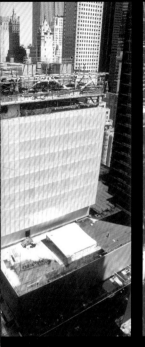
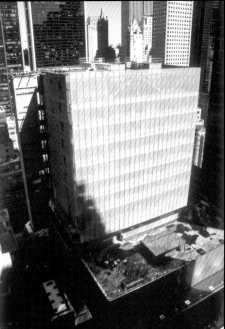

Produced by the Department of Publications,
The Museum of Modern Art, New York

Edited by David Frankel
Designed by Amanda Washburn
Production by Marc Sapir
Printed and bound in China by Oceanic Graphic Printing, Inc.

This book is typeset in MoMA Gothic, Franklin Gothic, and Trade Gothic.
The paper is 150 gsm New-G Matt artpaper

Library of Congress Control Number: 2004112661
ISBN: 0-87070-163-0

Image Credits

In reproducing the images contained in this publication, the Museum obtained the permission of the rights holders whenever possible. In those instances where the Museum could not locate the rights holders, notwithstanding good faith efforts, it requests that any contact information concerning such rights holders be forwarded so that they may be contacted for future editions.

© 2004 Timothy Hursley: pp. 6, 11, 16–17, 26, 32, 33, 36
© 2003 David H. Lombard: pp. 39–54
© Taniguchi and Associates: front and back cover, title pages, pp. 4, 8, 9, 12, 18, 19, 35. Photograph Toshiharu Kitajima: 25, 29, 30
© 2004 Michael Wesely: pp. 22–23. Reproduced courtesy of the artist

Pp. 16–17: James Rosenquist. *F-111*. 1964–65
Oil on canvas with aluminum (23 sections)
10 x 86' (304.8 x 2621.3 cm)
Collection The Museum of Modern Art, New York. Gift of Mr. and Mrs. Alex L. Hillman and Lillie P. Bliss Bequest (both by exchange)

Printed in China